I AM SO HAPPY RIG$T

Manifesto The Randomists

Randomism is an art movement dating from the early 21st century that utilizes a mechanism created by an artist for the purpose of generating random ideas. The ideas are then transferred to physical form using traditional techniques such as drawing, painting, sculpture and writing. An artist constructs their own mechanism, usually a software program but could be as simple as a dice roll, for the single purpose of creating artistic works. The goal of Randomism is for the artist to have zero accountability in any of their creations. Thus absolving them of any unforeseen affronts their work may invoke in a viewer. It is widely agreed among the movement that Randomism is a self defense mechanism in an age of hyper political correctness and barbaric worldviews.

For my best girl

The Sex and Lier Robin

A sweatshop in Europe of the c-clamp kind had a belief that the Bank of Duck China is fiction. It was an icicle made of Italian ox that beat the saxophone in the moon weight postbox. One of a toad and daffodil Gore-Tex toe cover from Burma, a kilometer from the tent for the insect rest. The governor of cylinder cream hourglass took his vase hook and plaster ferry from the Congo Balloon to Fiber Hill Freezer, an experience which he added to his buffer.

Wednesday of the Subway Shoulder

Lumber tire in April and porch night sex. It's the children that can add the wilderness stepmother and aftershave to a plate of punishment. Spike and leather, a fact like an ikebana wallet. And when the second forest voice came in the tent, numeric in its jumbo plane, swing boy quit his eyebrow and great-grandmother turtle lost her periodical wallet. Attention Rainstorm, the author of Calculus Action Sausage from

Carriage of Egypt and the Narcissus Flag

Sense of coffee and a hyacinth wrist of an aluminum camera tooth. Wallet, cry, rain, take the cake beetle on Saturday to the toilet and screen the curve of attraction to Brian in the CD fold.

Numeric

The temple sheet was a purchase of men. Its lumber makeup like a swordfish. Numeric hook and quilt crayon, oxygen with a manicure. The cinema title of "Loss Blowgun" was on cable, like "Coke Llama Noodle" in February. The pansy vegetarian face of winter in a cannon of Congo cyclone with the Swedish.

"Stomach slash of a parallelogram circle with a noodle panda"

Payment Underwear for your Step-aunt

The underpants police fell fowl of the apple. Save the ornament curtain of gladiolus with the croissant. Start to use the sled treatment for business in Puma as it's innocent of the dipstick Ocelot mother-in-law. Hardware from the postage lobster and b

Low Decision of Command Division

Quail note the rhinoceros desk bulb. It's memory of Spain and Jeff with the aluminum bull calculus. A patch of lace hoe with an option of oyster in tune with the brace of a seashore swordfish. The cougar copy in a fold of smoke parcel and the apple of the eagle overcoat on an island character its refrigerator full of hockey garlic.

The Deodorant Organ

The glass cable hurricane salesman Ash, with a polish oboe to his chest and a Kendo Elizabeth drawbridge. His cupboard pantry neck, grandfather and father-in-law (a Rabbi from Pine prison). Its stop-sign of flesh box planet and an interviewer with a dirt cockroach ophthalmologist. Advantage payment knowledge of star Iran border, the middle description vulture. A machine of soil and wolf piano. The blanket secretary whorl, Sharon, is a patient theater of Ukrainian armadillo drug.

"Get the detail trigonometry for fear of the territory balloon cactus"

Coal Bull the Joke Cow

The crocodile quince had a mailbox banana. A duckling tie of a sister-in-law on his windshield of a beauty slope. Law Claus the great-grandfather of Kimberly Toilet had a tree paste swan in a music parcel and a theater of an eel kiss.

Taxi for Brian Foxglove

It was a beet database of corn hardboard that was unshielded in Algeria. The inventory of a tadpole, a pizza, a diploma cloakroom and a kettledrum was interactive in the address to trail the Australian lilac wrist parrot. A precipitation of ox lobster and a pediatrician washer was in the drain but their chauffeur was a guilty railway.

Touch the Innocent

Dirt sugar and trout, a zone front organization of samurai, a suggestion verdict of a fiction thermometer and jail for the loaf tile. The peen fragrance of hate cook the Saudi Arabia art. A polyester sort yam with a partridge play agreement. Zephyr jail had bean rain, the judo instrument of the toast? A ketchup fog!

Eyeliner on the Windscreen Manager

It was a segment pansy composer that was to support the d

"The vegetarian wealth appendix is a ton of nitrogen mustache for Ruth Tray"

A Cockroach Cart and a Lilac Pruner

Laugh to revolve the band of the half-brother plow and the single stream truck. The sun playroom has a hardware flag, tuba net and a thing swimming in Russia. The finger of Christopher cross the girl with a monkey knee in a glove the daughter made from a loaf.

Thailand Expert Insect

www.ricallinson.com

First published 2013

ISBN 978-1-304-34442-7

Copyright © 2013 Richard S Allinson. All rights reserved. No part of this publication may be reproduced or distributed in any form or by any means, or stored in a database or retrieval system, without the prior written permission of the publisher.

Designed by Richard S Allinson
Printed by Lulu.com

Picture Credits
Unless otherwise stated all images are courtesy of Richard S Allinson.

www.ingramcontent.com/pod-product-compliance
Lightning Source LLC
Chambersburg PA
CBHW070434180526
45158CB00017B/1207